DIRTY WOW WOW
and other love stories

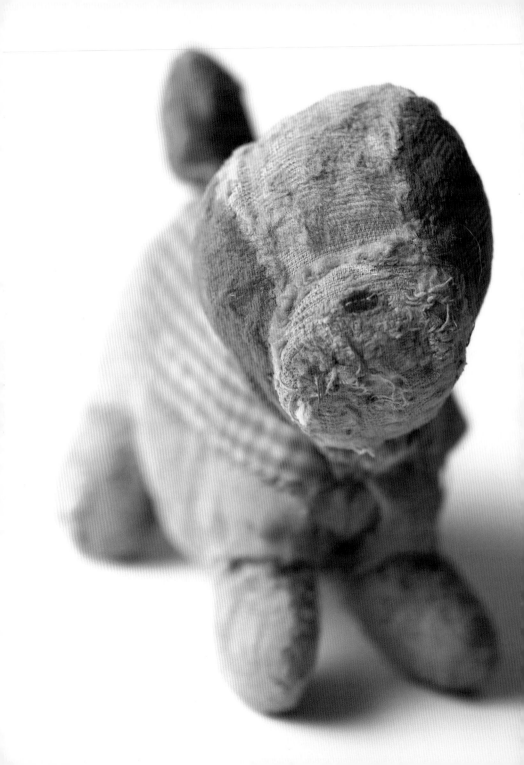

DIRTY WOW WOW

and other love stories

A tribute to the threadbare
companions of childhood

Cheryl and Jeffrey Katz

PHOTOGRAPHY BY Hornick/Rivlin

TEN SPEED PRESS
Berkeley | Toronto

1🠺

Ten Speed Press
PO Box 7123
Berkeley, California 94707
www.tenspeed.com

Distributed in Australia by Simon and Schuster Australia, in Canada by Ten Speed Press
Canada, in New Zealand by Southern Publishers Group, in South Africa by Real Books,
and in the United Kingdom and Europe by Publishers Group UK.

Cover and text design by Nancy Austin
Cover photography by Hornick/Rivlin

Library of Congress Cataloging-in-Publication Data
Katz, Cheryl (Cheryl B.)
 Dirty wow wow and other love stories : a tribute to the threadbare companions of
childhood / Cheryl and Jeffrey Katz ; photography by Hornick/Rivlin.
 p. cm.
 Summary: "A nostalgic collection of photographs accompanied by short
essays featuring the well-worn and beloved toys, dolls, and stuffed animals
of childhood"–Provided by publisher.
 ISBN-13: 978-1-58008-832-9
 ISBN-10: 1-58008-832-5
 1. Photography, Artistic. 2. Soft toys–Pictorial works. I. Katz,
Jeffrey (Jeffrey P.) II. Title.
 TR655.K365 2007
 779'.97455924–dc22
 2006034391

Printed in China
First printing, 2007
1 2 3 4 5 6 7 8 9 10 – 11 10 09 08 07

For Fanny and Oliver

CONTENTS

INTRODUCTION

\mathcal{O}ne evening over dinner, we were talking with our friend Jim about our idea for a book about childhood love objects. Jim is a smart and supportive father of two incredible kids, a kind and gentle husband married to his college sweetheart, and one of our more macho pals. He has an image to uphold—one that a worn-out, sweet-faced childhood love object does not necessarily support. As it turns out, Jim is not as macho as he seems.

Revealing that he thought he might still have the object of his boyhood affection ". . . upstairs somewhere. I think my mother sent it to me a few years ago . . ." Jim left the table—and returned in about fifteen seconds with said dog. Our initial suspicion—that Jim was attempting to disengage himself from his "doggy" by assuring us that he hadn't deliberately kept it with him all these years—was confirmed. Jim lives in a fairly large house, and if he hadn't known exactly where that cute little guy was hiding, it would have taken him a lot longer to find it. When Jim returned to the table, we oohed and ahhed over how adorable it was, and then asked the obvious: What's its name? We were floored when Jim told us he didn't remember, but he promised to ask his mom.

For most of us, naming our favorite childhood object was critical because it gave the thing humanity. A name allowed a plush and inanimate

object to become part of the family. A name allowed us to ask our parents to kiss so-and-so good night just after they'd kissed us. For many of us, the name of our beloved toy is all that remains—the love object itself lost or abandoned long ago.

We both had cherished stuffed animals who are now just fond memories. Cheryl had Farfel, a terrier named after a character in a commercial for Nestlé QUIK, and Jeffrey had Toppy, a pink plaid elephant sporting a beret who was named for the 1950s-era Top Value stamp program, through which Toppy was procured.

Even though he's no longer with us, Farfel played an important role in the bedtime rituals of our children, Fanny and Oliver. If Jeffrey put the kids to sleep, he read them books; when Cheryl put the kids to sleep, she told them Farfel stories. At first, the stories were true, but once Cheryl ran out of true Farfel stories, she had to make them up. Fanny and Oliver called them "mouth stories" because they didn't come from a book. The kids teased Cheryl mercilessly because sometimes her Farfel tall tales turned into Farfel gibberish as she tried unsuccessfully to fight off sleep.

Fanny and Oliver both had beloved objects that got tucked into bed with them every night. Fanny had Ollie, and Oliver had Doggie (Ollie, Oliver— we know, it's complicated, but more on that later). We have fond memories of waiting for Oliver to fall asleep so we could sneak Doggie out of his bed and perform some emergency surgery before they went off to summer camp. On the verge of spending seven weeks in a tent in Vermont, Doggie needed to be restuffed and stitched up. As Doggie became a preteen, repair work became more challenging. Like the face of an aging movie star, Doggie's skin became alarmingly taut over the years. He got skinnier and skinnier with each repair. When the rips and tears got really big, we grafted rags over the holes, stitching around the edges and causing unsightly splotches. Fortunately, Oliver never minded much. Kids don't seem to notice the slow disintegration of their constant companion.

Oliver's grandmother, whom some might describe as being obsessed with cleanliness, once tried to replace this scraggly, smelly, gray-that-used-to-be-white dog with a fluffy fresh new one straight from FAO Schwarz. In her mind there was no contest—Doggie would be forgotten in no time at all. Acquisitive creature that Oliver is, he loved this new dog too, and immediately added it to his menagerie of overpriced stuffed animals (most of them bribes) crowded on a shelf in his bedroom. And much to his grandmother's chagrin, it sits there to this day, a dozen years later, unnamed, rarely touched, and clean as the day she bought it. Doggie, on the other hand, is also still with us, skinnier, dirtier, as loved as ever, and possessing that unique smell that inhabits the tip of his tail. The tail that, when Oliver gently tucks it under his nose, instantaneously transports him back to the overstuffed chair in the living room where he sat as a toddler and considered the events of the day.

This book is the result of our search for the beautiful, soulful, well-worn, and beloved objects that eased us through childhood—our ballast against the uncertainties of youth, and our best friends for life. At first we collected objects that we knew firsthand. As word about the book spread, we started hearing stories about lovies from all over. Our only criteria for inclusion was that each be as photogenic and unique as we imagine Farfel and Toppy would be, had they survived.

Oh, and Jim's mom finally called back. His little dog did indeed have a name, and it's a curious one at that. His name is Dirty Wow Wow, but nobody can remember why.

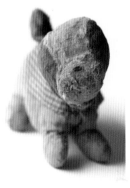

DIRTY WOW WOW

and other love stories

DOGGIE

*W*hen Doggie was nine years old, he went to Paris with Oliver. He mostly stayed in Oliver's backpack, but at just the right moments he was hauled out and made to pose in a coy manner, like a highly paid French fashion model. He was photographed all over Paris: Doggie atop the Eiffel Tower, Doggie under the Arc de Triomphe, Doggie in front of the pyramid at the Louvre. Exhausted but culturally enriched, Doggie returned home.

Although it was Doggie's European adventure that originally inspired this book, alas, it was his last. Aside from a couple of weekends in New York and summer camp in Vermont, Doggie now lives a simple life in Boston.

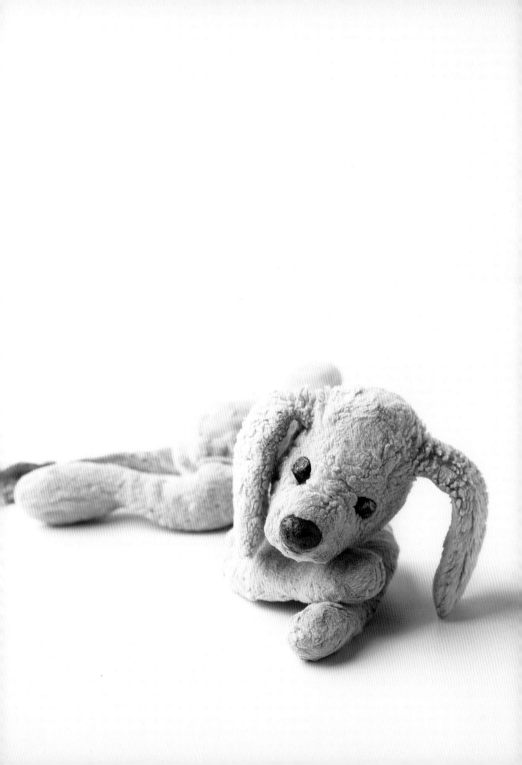

GONKS

*I*t's clear that Gonks has a big heart and that he's the kind of guy who stands out in a crowd. When he enters a room, his orange hair, goofy grin, and lanky, flowery limbs make it hard not to notice him. But this wasn't always so. Back in the days of disco, Gonks resided in Julie's bedroom, which, de rigeur in those days, was done up in hot pink and lime-green flowered wallpaper. In such psychedelic surroundings, Gonks was nothing more than a wallflower.

Disco decorating safely in the past, Gonks has now returned to his rightful place in the limelight.

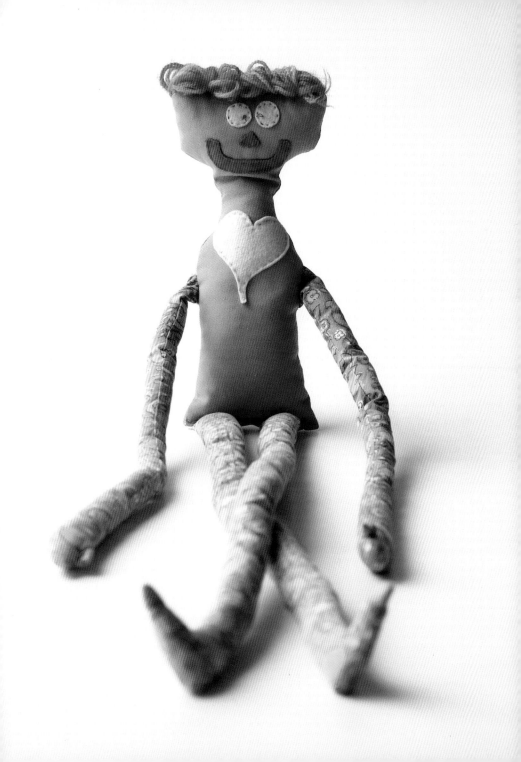

WALA

For a ten-year-old, Wala has had a tumultuous life. At one year old, he spent an entire night alone in the park. During a blackout, he was accidentally burned with a candle by Jake's older brother, Ben. Wala has had about twenty surgeries to repair various tears to his skin. His nose has been broken and his glass eyes scratched more than once. After a particularly energetic game of toss between Jake and Ben, Wala had to have pellet replacement surgery, so now he's filled with mung beans. On the love front, he is currently involved in an intense romance with Sally McBear. Even though Sally is rumored to be imaginary, it doesn't stop Wala from breaking up with her on a regular basis.

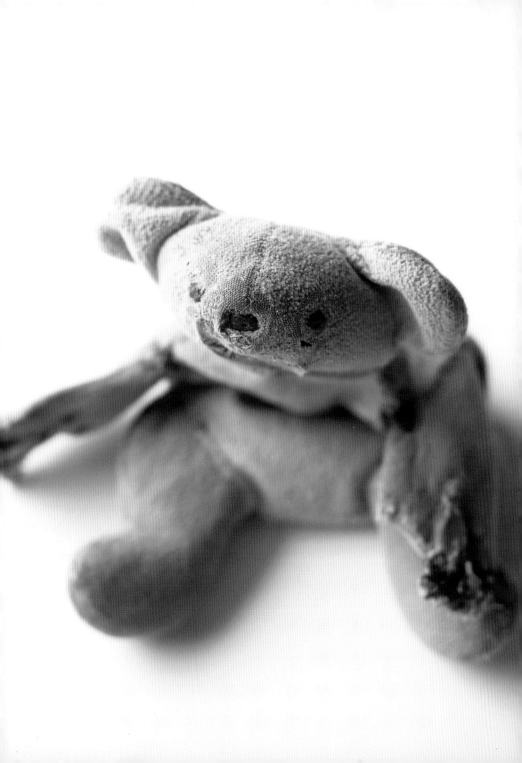

PORKY

*W*hen Michael brought the woman he intended to marry home to meet his parents for the first time, Porky got trotted out to greet her within minutes of their arrival. Michael remembers the incident as beyond embarrassing. Though he might have been embarrassed that Porky existed at all, it's also possible that Michael was humiliated by Porky's new blue "paws." Presumably an upgrade from the old tan ones, Porky's new paws were added after Michael left for college, an improvement that he still finds unsettling.

Undeterred, Wilma married Michael anyway.

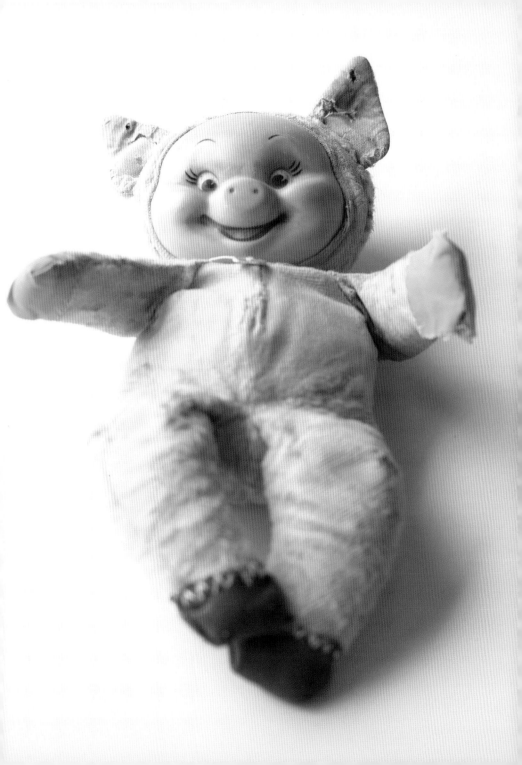

TEDDY

\mathcal{A}s witness to every major transition in Lydia's life, Teddy is as significant a companion as they come. Across three continents and through several moves, her parents' divorce, sleepaway camp, and even Lydia's first kiss, Teddy has been a silent and supportive friend. When one of Lydia's boyfriends hid Teddy because he was jealous of her fidelity to the bear, such paranoid behavior only increased Lydia's resolve to keep Teddy close.

She will surely turn down any man who can't respect Teddy.

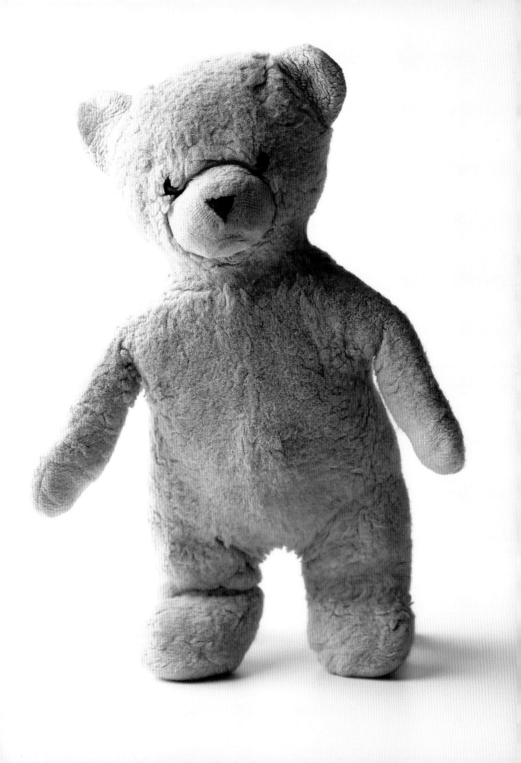

BLANKIE

*B*lankie lives in the liquor cabinet.

When little Maggie fell asleep clutching Blankie's lovely silky edge—
a fine thing to do when you're trying to get some shut-eye—she was also invari-
ably sucking her two middle fingers. This made Maggie an orthodontist's dream.

One day Blankie disappeared. When he was discovered weeks later,
behind the curtains, Maggie was already weaned from him. Maggie's mom
saw this as an opportunity to let Blankie stay lost and shoved Blankie into the
liquor cabinet above the refrigerator.

Now, whenever a recipe calls for brandy, Maggie's mother catches
a glimpse of Blankie and feels a pang of guilt. But not $5,000 (the cost of
Maggie's braces) worth.

GREEN EARS

Andrew's grandmother understood the particulars of tailoring, so she approached the design of Green Ears as if creating a bespoke suit. She considered the precision of each stitch, the look and feel of the fabric, and the exact color of the lining, thus fashioning a dog that fit Andrew to a tee. But unlike an outgrown or no-longer-fashionable suit that gets tucked in the back of the closet, Green Ears sits in a place of honor on the bookshelf in Andrew's study—the lining of his ears faded, but stylish as ever.

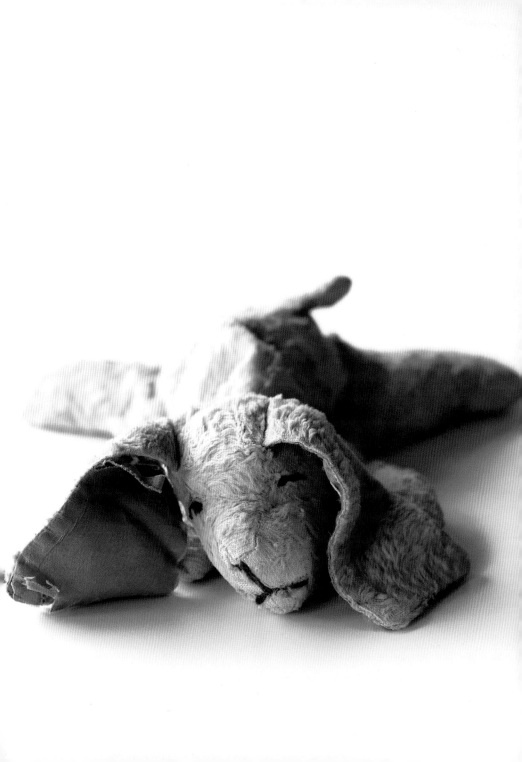

BAND-AID BEAR

*F*ull disclosure: nobody knows the real name of this bear. It's not that it wasn't loved; that much Michael knows for sure. But since most lovies are named for their salient feature—Blankie, Doggie, Fuzzy—what could you possibly call this optically challenged little guy but *Band-Aid Bear*? The Band-Aid was affixed with the best intentions by Michael's mom. The bear was missing an eye and this cure was close at hand—unfortunately, what was supposed to be a subtle fix turns out to be, like a bad toupee, the one thing you can't help staring at. You can't look at Band-Aid Bear for one second without thinking "boo-boo."

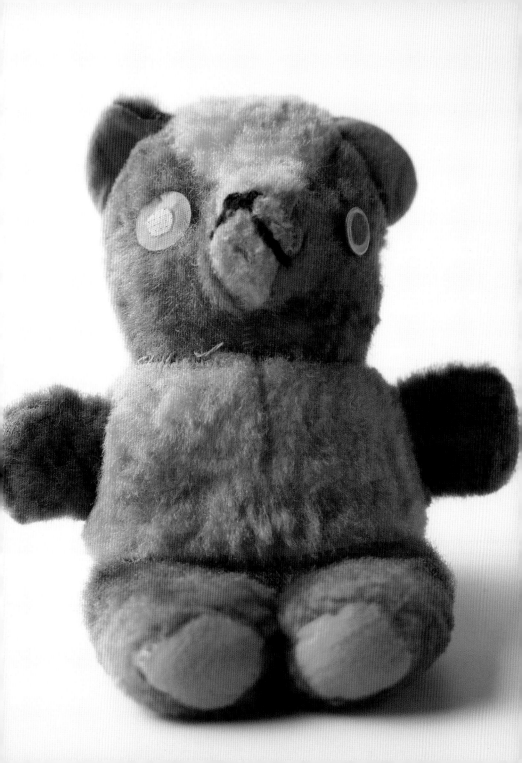

QUINN

When Hervé was a boy living in France, he was devastated when he lost Blanchette, his little white goat. Coming to the rescue, Hervé's mum retrieved Quinn from the closet where he had been tucked away for safekeeping. To comfort her bereft son and make the gift seem really special, she told Hervé that the donkey had been a baby gift from the famous actor Anthony Quinn. Quinn the donkey and Hervé developed an immediate mutual attachment and Hervé never thought much about Blanchette again. Hervé was a grown man when he learned that his little white goat had been replaced by a little white lie in the form of a little blue donkey.

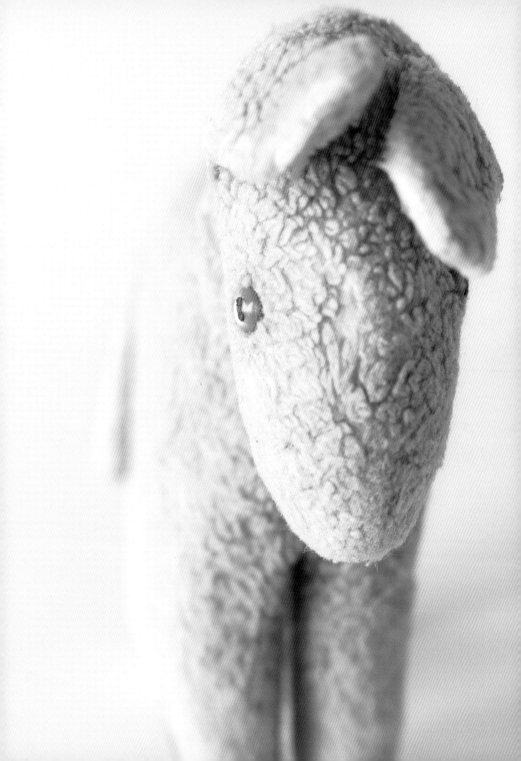

BEAR

*H*e hasn't worn his blue vinyl raincoat and red hat in years, but even without his trademark suitcase, you'd know right away that Bear is actually Paddington Bear. That isn't his name, though. It is simply Bear, because as far as teddy bears go, Nathan secretly preferred Corduroy.

Nathan's mom, a children's librarian and rather partial to (some might say, a little obsessed with) the Paddington stories, hung a poster of Paddington Bear on the wall of Nathan's room. Now that he's grown up and a philosopher, Nathan remembers this being a little creepy. Here next to him was Bear, and there on the wall was Bear. Nathan feels that perhaps the poster undermined the oneness of Bear.

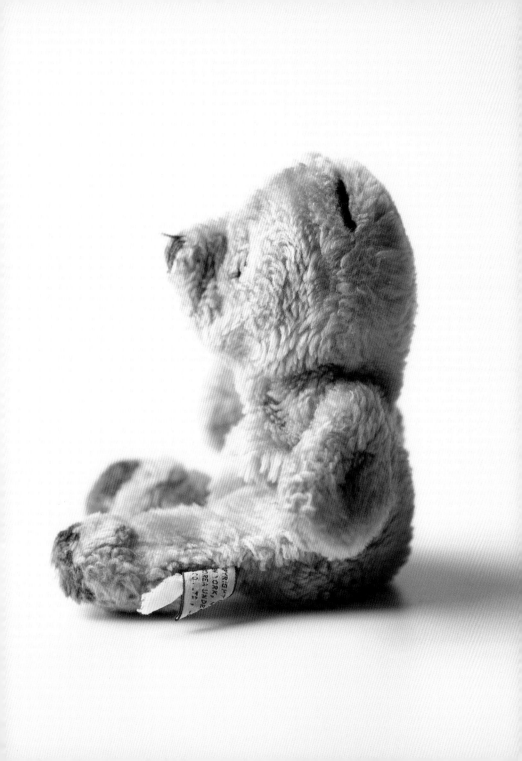

BUNNIE

*C*urrently naked as the day she was made, Bunnie wasn't always such a free spirit. A decade ago, with a coat, three dresses, a skirt, and a sweater, Bunnie might have topped the best-dressed list. Six-year-old Jenna, aware that a good outfit is finished only when the hair and makeup is just right, concocted some great looking hairdos for Bunnie.

But clothes and coifs weren't Bunnie's only adornment. Occasionally Bunnie would fall out of bed; the only remedy for her injuries was a plaster cast. Usually it was just an arm or a leg that needed to be immobilized, but once, when Bunnie broke her head, she needed a full head cast with two little holes for her ears.

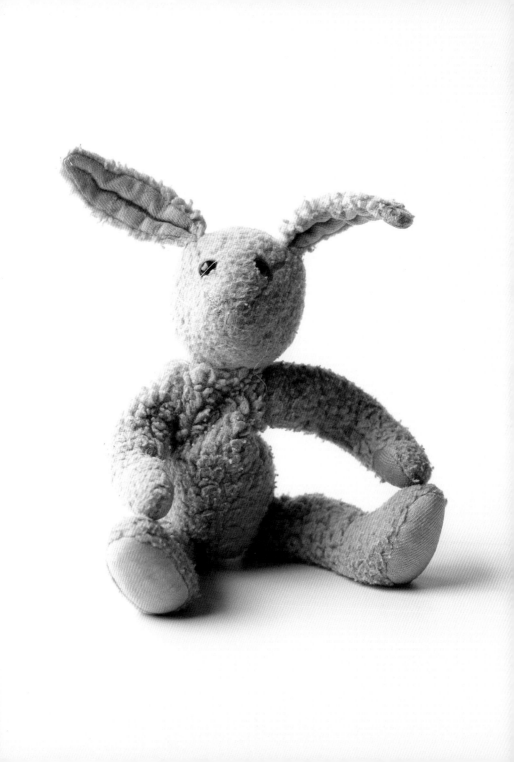

DOG

\mathcal{W}e don't know if it's the piercing gaze, the bright red tongue, the sturdi-ness of the stance, or the fact that he's made of rubber—but there is something curiously strange about Dan's Dog.

This perky little friend mysteriously disappeared during one of Dan's family's frequent moves. A few years ago, Dan and his wife, Judy, were walking through an antiques fair. Dan had the eerie sense of being watched, and turned to find Dog peering at him from the top of an old chest of drawers. After all these years, Dan and his indestructible Dog are reunited.

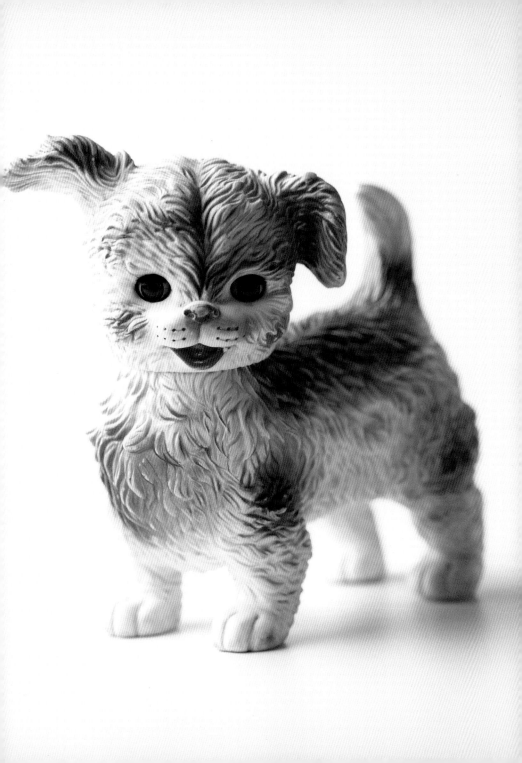

FLOPPY

*T*he downside of having a laundry service wash Carol's sheets every week was that Floppy often got tangled up in them. Those were the days when Floppy was completely white, and it was difficult to distinguish him from his surroundings. Floppy's inadvertent excursions to the laundromat not only caused Carol a huge amount of anxiety, but also did significant damage to Floppy's soft coat. An unexpected benefit of repairing Floppy with colorful fabric was that his bed-linen camouflage was undone—and he was never laundered again.

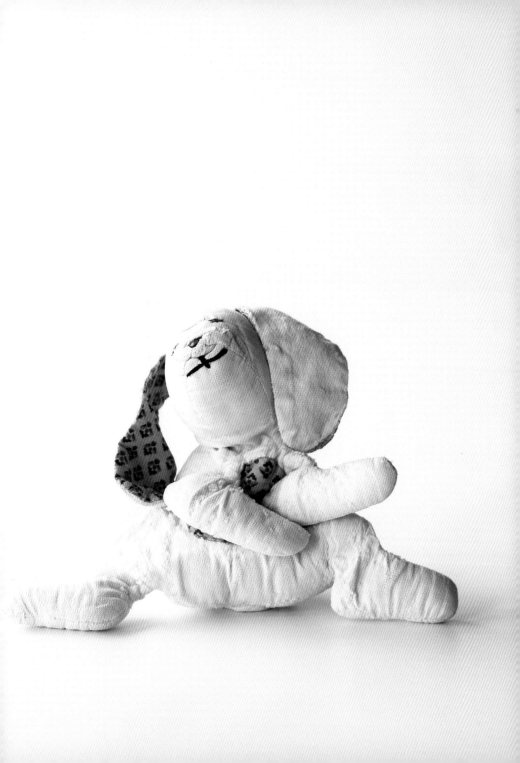

GABRIEL

Growing up in a household that prized books and disallowed TV and rock music, Andrew was a serious child, wise beyond his years. But he was a child, after all, and the darkness that settled around him at bedtime was frightening—until Gabriel arrived. With his proper posture and good listening skills, Gabriel could be counted on to offer comfort during the night, especially after the "If I should die before I wake" part of bedtime prayers, which Andrew found particularly scary. Andrew's not afraid of the dark anymore, but he still likes books, listens to classical music, and takes comfort in Gabriel's presence.

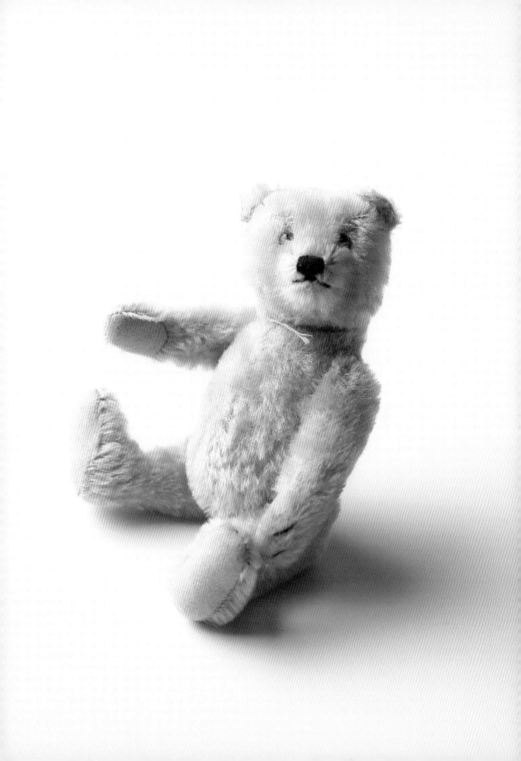

TWIN BUNNY

*N*either a bunny nor a twin, Bunny was actually a blanket that covered Sam every night in her crib. Sam constantly rubbed Bunny's fringe, which caused Bunny to sprout tangled nubs of various shapes and sizes. As Bunny unraveled and finally disintegrated, one particular nub became Sam's treasure, but it was so small a treasure that it would invariably get lost in the bed, causing Sam to wake her weary parents two or three times a night. During one sleepless interlude, Sam's mom had a brainstorm. She tied what was left of Bunny to another full-size blanket and Twin Bunny was born, allowing sweet dreams and restful nights for Sam's entire family.

SMOOCH 2
(AKA HAPPY BEAR)

*L*ovies rarely survive to be passed down from one generation to the next, but when they do, they're special. Extremely well-loved, these creatures usually look old beyond their years. Case in point: Smooch 1. Although he did get pretty worn out, Sammy's mom was clever enough to keep a duplicate–Smooch 2–in good enough shape to pass along to her firstborn. Sammy, an independent soul, promptly renamed him Happy Bear. A little worse for wear, Happy Bear's physical state may portend the end of the generational legacy.

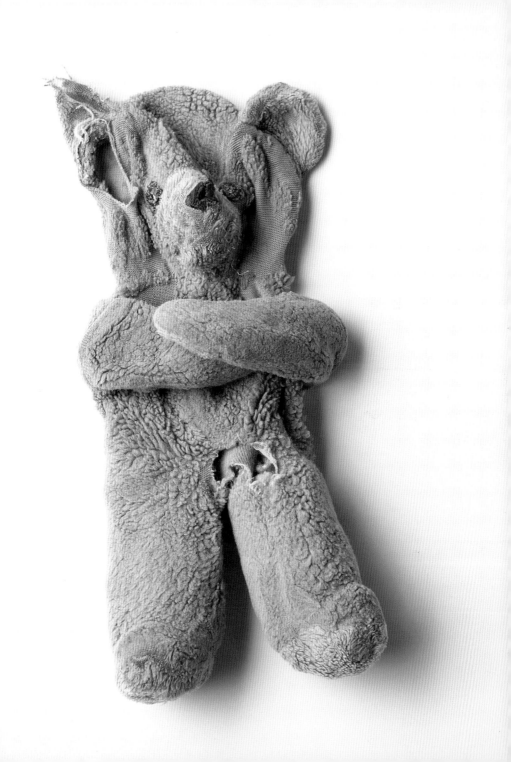

OLLIE

When Fanny was very little she had four favorite dolls: Dolly, Molly, Saulie, and Ollie. Eventually, Ollie became her most favorite, which created confusion when her brother, Oliver, was born. There had been a long deliberation about what to name Oliver, but in all those discussions it hadn't occurred to Fanny's parents that Oliver would soon be called Ollie, just like Fanny's favorite toy.

"Where's Ollie?"

"He's upstairs stuck under my bed."

"Oh my god! Is he okay?"

After a while, everybody in the family agreed to call Fanny's doll *Ollie* and Fanny's brother *Oliver* because, after all, Ollie came first.

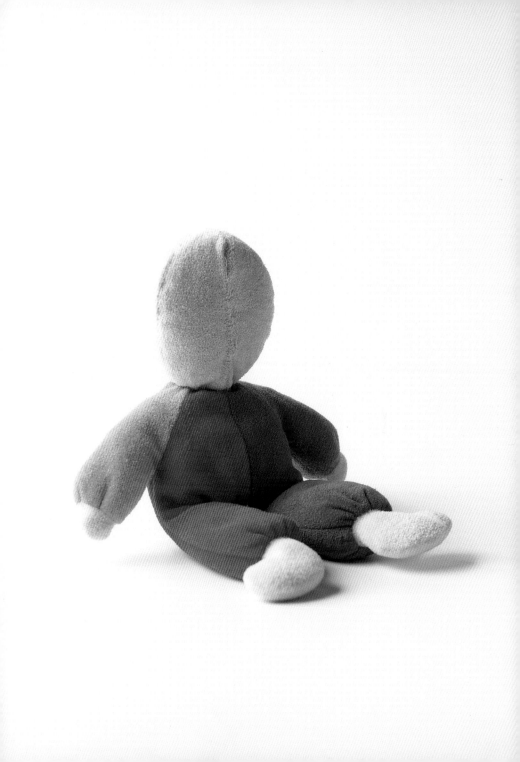

FUZZY WUZZY

When Pete's first child was born, he received a package from his mom containing this well-worn panda. Lifting the panda out of the box, Pete thought he looked vaguely familiar and realized, strangely, that he knew his name. But that's where the memories ended; as if he were waking up the morning after a hard night of partying, Pete's recollection of the details of his life with Fuzzy Wuzzy was, well, fuzzy.

Over the years, Fuzzy Wuzzy stayed in the attic. Occasionally Pete would run across him, and again he would experience that nagging feeling of not knowing the whole truth about his relationship with Fuzzy Wuzzy. "How close were we?" Pete wonders. "Did we watch *Howdy Doody*? Did he come with me to the beach house during the summers? Did we sleep together?"

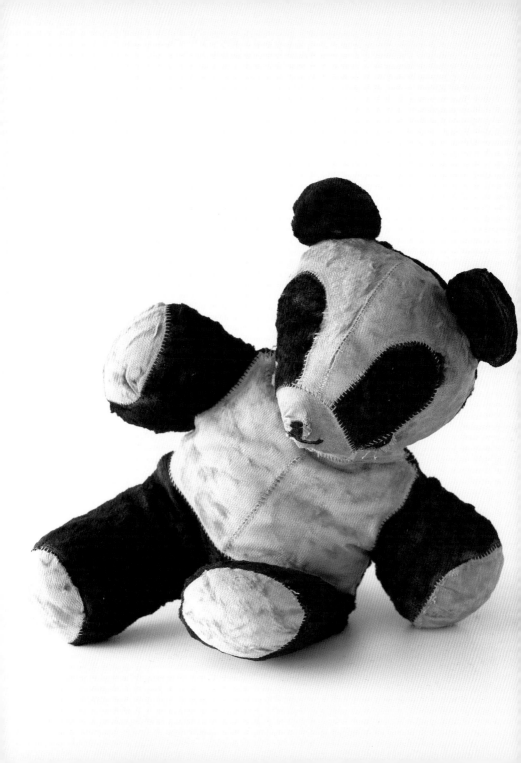

NIGHT NIGHT

*E*ight-month-old Jeannie WanZhi was wearing traditional split pants when the orphanage nanny placed her in her new mother's arms. During their first few nights in China, her mother would place WanZhi's pants, now known as Night Night, in her crib so she would have something comforting and familiar nearby. As time went on, Night Night and Jeannie WanZhi became inseparable.

Although the Miss Kitty print adorning WanZhi's orphanage pants has long since washed away, the almost frantic pattern of telephone numbers, written in indelible ink on the inside of the pants, remains to ensure that WanZhi and Night Night stay together forever.

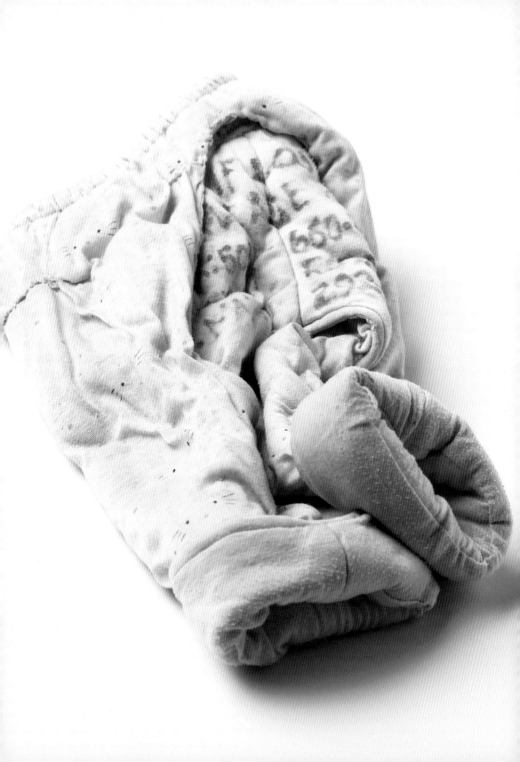

HAIRLESS

*H*and sewn by Polly's great-great-great-aunt, Hairless was passed down through the generations and came into Polly's keeping when she was eight years old. In those days, Hairless had not only her arms and legs, but also a small sunbonnet that covered her bald head. First the sunbonnet disappeared. Years later, Hairless fell prey to one of Polly's ill-conceived college art projects, and her arms and legs disappeared as well. But Hairless's substantial sacrifice wasn't all for naught. Polly, now a well-respected illustrator, is known for her small constructions composed of many peculiar things—including little arms and legs.

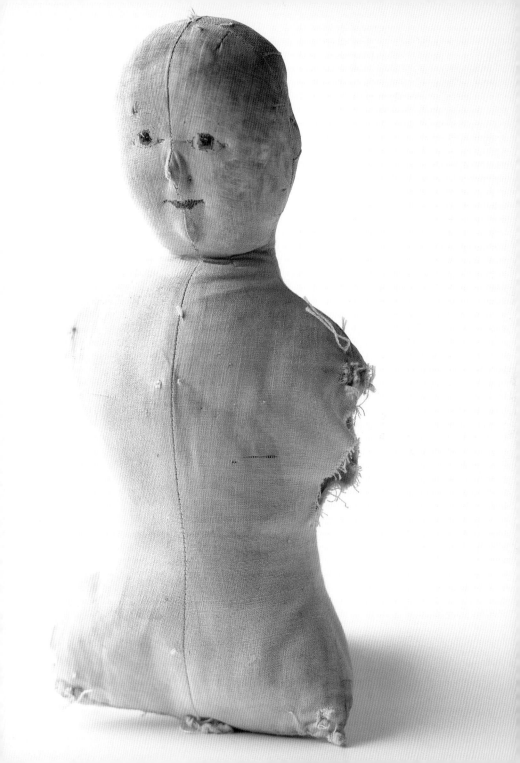

BUN BUN

*W*ill loved Bun Bun for lots of reasons. His back seam was ripped just enough for Will to hook his finger into as he fell asleep. Bun Bun's skin was soft enough to rub under Will's nose. And his body was small enough to hide under the bed when Will got too old to leave Bun Bun in full view of his friends. But Bun Bun's most endearing attribute was his ability to nurse Will back to health whenever he fell ill. No cough medicine, aspirin, or antibiotic ever worked as well as Bun Bun. Even Will's doctor mom couldn't explain it. That's why Bun Bun's alias is Will's Ill Pill.

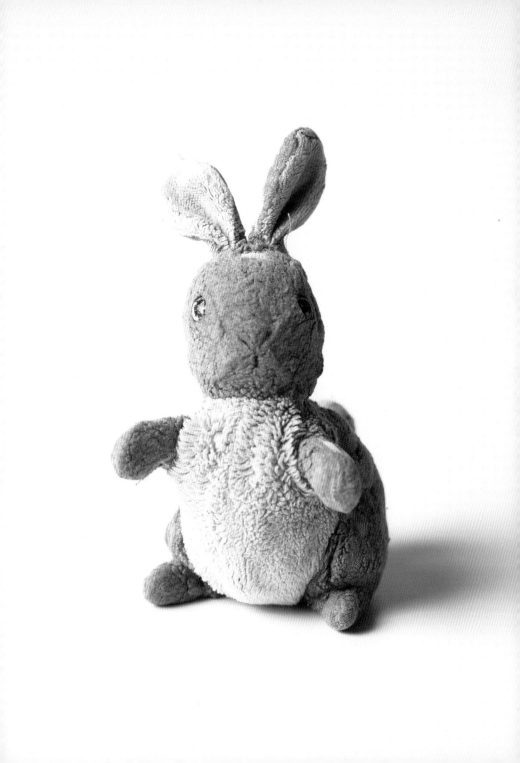

EEE-EEE

A lively and free-spirited monkey, Eee-Eee doesn't think twice about donning vestments that belong to other dolls. Lisa has dressed him in a cowgirl sweater set, a colonial dress, a yellow Fair Isle turtleneck sweater, and a pink tulle skirt—often all at the same time. Eee-Eee is obsessed with bananas, and his girlfriend is a huge pink gorilla named Pink-Eee. If you haven't already guessed it, Eee-Eee is from California.

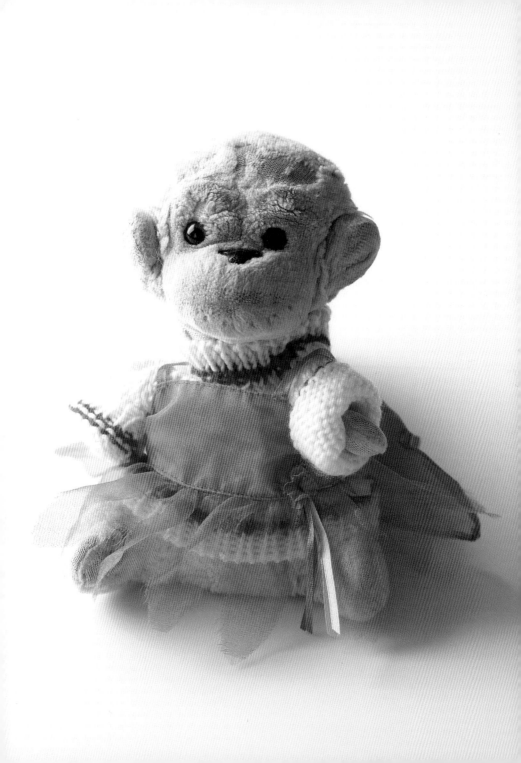

HUGGIE

*A*lthough Huggie's ample bottom may appear to keep him earthbound, he's actually a skilled flyer. During a family car trip to Florida, Huggie became the object of a vigorous backseat game of catch between Nina and her brother. On one particularly poor shot, Huggie flew right out the window! Nina's dad exited the highway and hurried back to the site of Huggie's launch, where Nina found him unharmed and only slightly the worse for the crash landing. Now when Huggie ponders the heavens, he remains firmly seated on the ground in gravity's good graces.

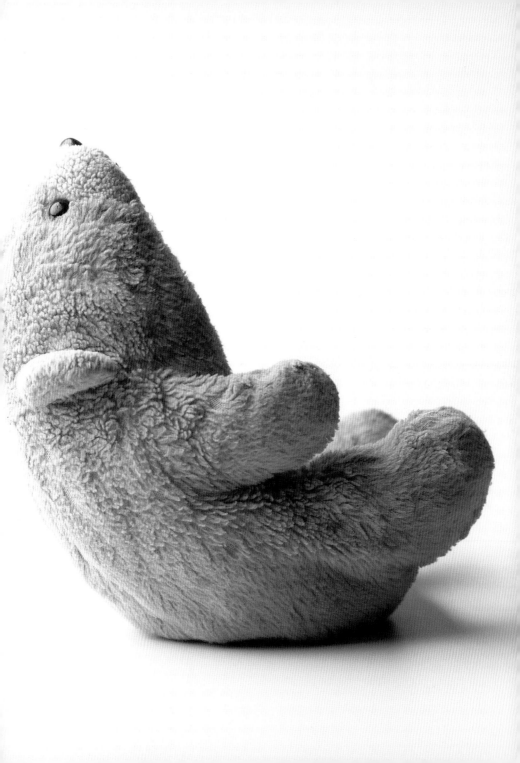

MAMMA

*N*ora's grandmother made Mamma in 1952. The beautiful craftsmanship and ladylike ensemble suggest that Mamma is worthy of respect; she is nothing if not dignified. Nora's college roommates, however, felt otherwise. After an evening of studying in the library or carousing with friends, Nora would often return to her dorm room to find Mamma on the coffee table, posed in compromising positions with Nora's roommates' toys—horses, clowns, what have you. Mamma may have been conceived by Nora's dear grandmother as a proper lady, but twenty years later—in the era of free love and feminism—Mamma became a symbol of the sexual revolution.

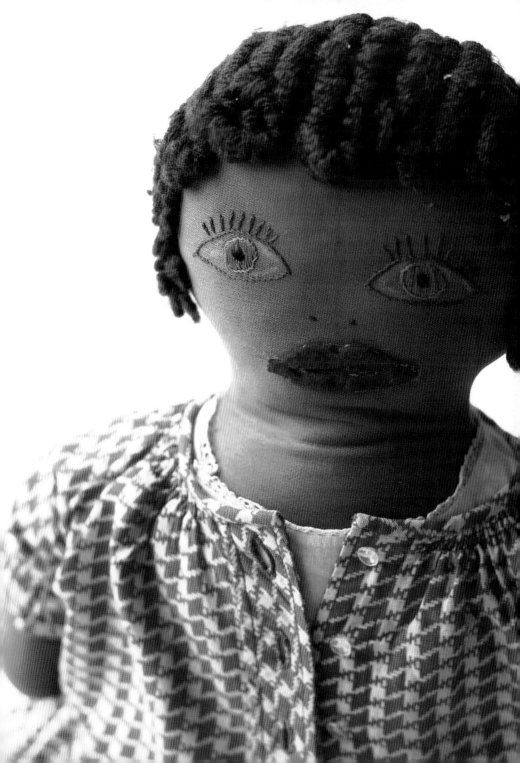

HAROLD

*H*arold Oscar Siemor III may seem like a long and pretentious name for such a small chipmunk, but he is, after all, made from real fur. Yes, there was a Harold Oscar Siemor I, as well as a Harold Oscar Siemor II, but the McBride family is a rowdy lot, and not nearly as refined as the Siemors. Fortunately, there were plenty of chipmunk descendants in the store where Mrs. McBride worked, so as first Harold I's tail and then Harold II's got ripped off during roughhousing, there was yet a third generation ready to take its place in the family lineup.

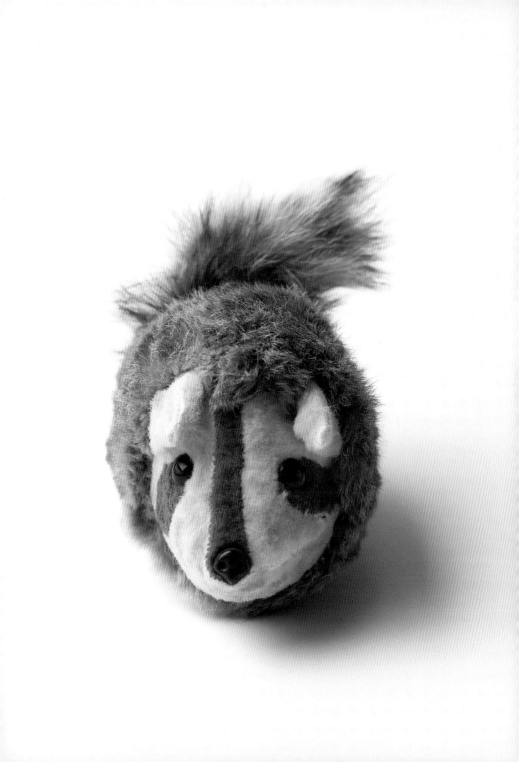

LEADBALL

*T*he feather pillow that Dave's great-grandmother made for his grand-
mother looks harmless enough, but it's a little stinky. When you try to lift it, the
true nature of Leadball shines forth: the thing weighs a ton.

Sometimes we underestimate the long-term effects that a well-loved
object can have on its owner. Leadball, for instance, has yet to loosen its grip
on Dave. Years of hoisting Leadball into bed have made Dave so strong that he
now trains others at the gym before and after his day job as a public defender.

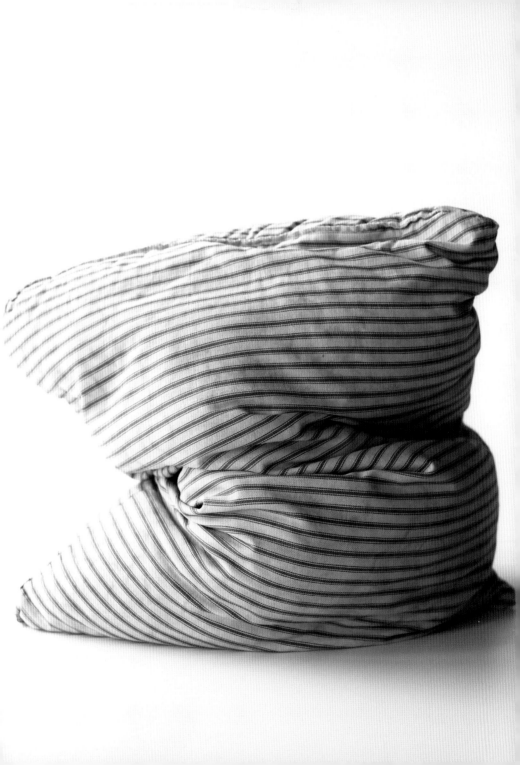

ERNIE

\mathscr{B}ecause Owen doesn't possess the benefits of language, mobility, or self-sufficiency that most of us enjoy, it's often hard to determine what he is thinking. That is, unless Ernie is around. Ernie's presence has never failed to bring a huge smile to Owen's face, even back when he was a baby. Why Ernie? Owen's mother, Kathy, thinks it's because Ernie's face is so darned friendly. He's open and welcoming and happy; he looks right at you and he never makes a judgment. For Owen, finding a friend who has all of those traits is, unfortunately, extremely rare.

One day, Owen and Kathy were in the park when Bert and Ernie, who were taking part in a promotion for *Sesame Street*, approached Owen in his wheelchair. When Owen saw the real, life-sized version of his beloved Ernie, a look of pure adoration filled his face. This experience is the source of the only regret Kathy has had while raising Owen—that she didn't have a camera with her that day.

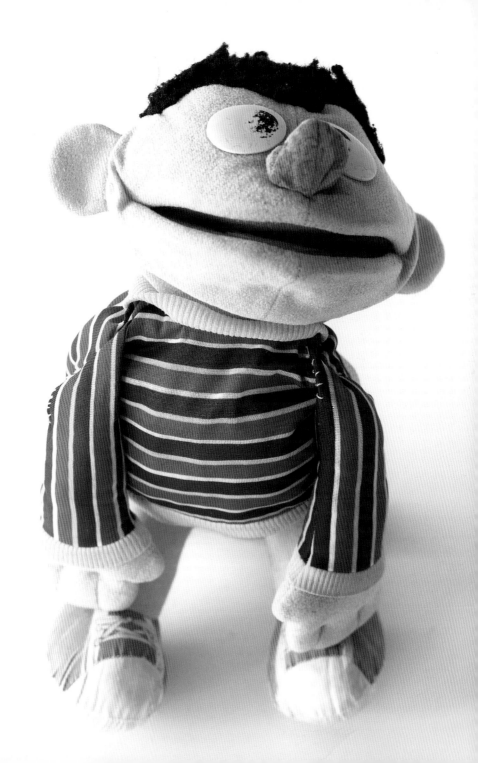

ONNETTE

\mathcal{O}nnette suffered many indignities during his tenure as Betsy's favorite play-mate. He spent countless hours taking high tea with the Puffalumps, drawing with the pint-sized Pinky Lover (who frankly was never much of an artist), and sailing through mud puddles with the Smurfs. However, the most humiliating game that Onnette had to play was "The Princess and the Pea." Too small to be the princess, he was cajoled into playing the pea and forced to spend hours at a time squished beneath Betsy's mattress. For all of this torture, Onnette is surprisingly unscathed, other than sporting what some might describe as a shockingly erect trunk.

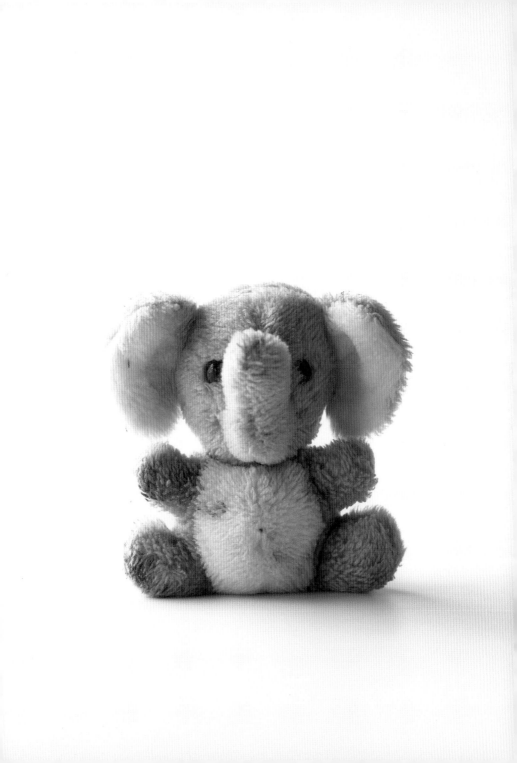

THOMAS

*W*hen little Evelyn awoke to find a bloody gash on her elbow she wondered how she could have sustained such an injury overnight. Hadn't she been sleeping peacefully with her beloved Thomas by her side? The mystery was solved when Evelyn's mum made up the bed and found a piece of Thomas's glass eye among the linens. A broken eye was only the beginning of Thomas's travails: next his tail fell off and had to be reattached, then he lost an ear. But all's well that ends well . . . Evelyn's gash healed years ago and she's taken care of her sight- and hearing-impaired bunny ever since.

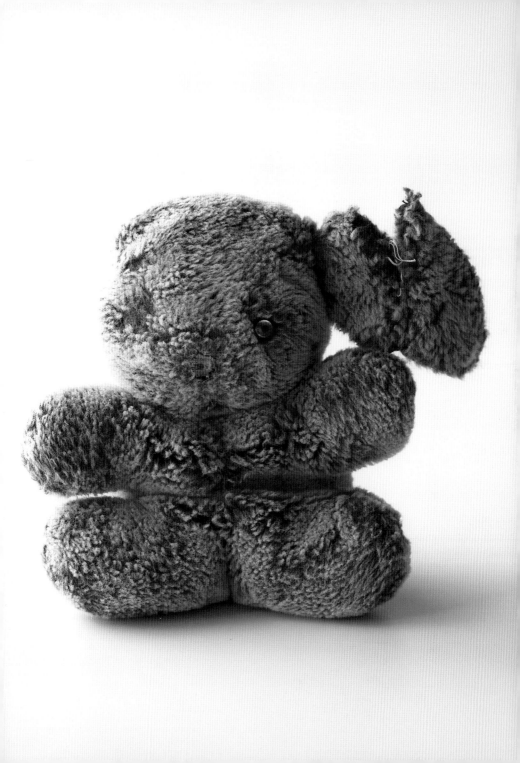

BLANKIE BELMONT

*A*t first glance it may not be obvious that Blankie Belmont is a scholar. We'd always known that Blankie's owner, Jessie, who is in college, was a successful student, with good grades and a great work ethic. But now we know the tattered truth. "Blankie's done years and years of homework on my desk," she told us.

Last we heard, Jessie was researching preservation methods for Blankie. We can only surmise that she's considering graduate school.

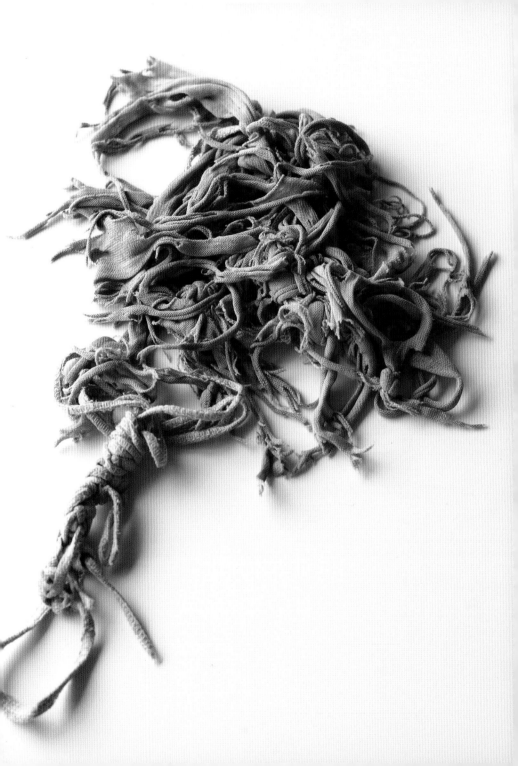

CLOWNY

\mathcal{L}ike all ambitious clowns, Clowny went to college. He didn't actually attend college, but he went there with Dave. And he lived in Dave's fraternity house for three years. You probably won't be surprised to learn that Clowny's fraternity brothers never even knew he was there. If they had known, just imagine what Clowny's face would look like now.

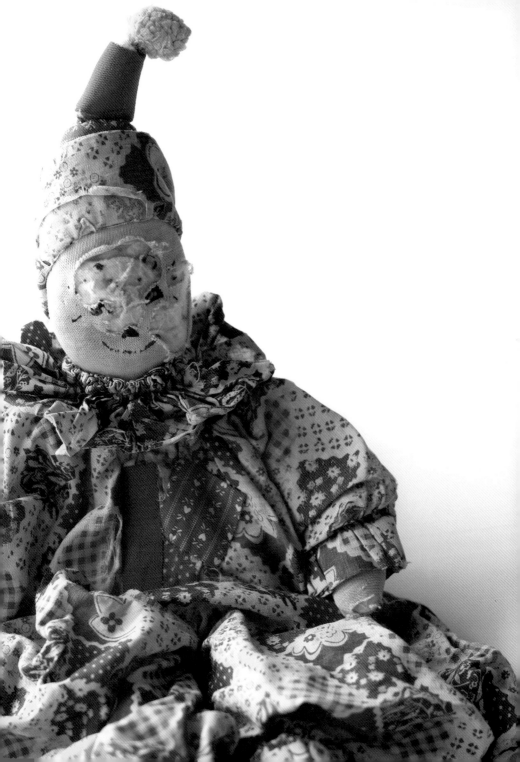

OWL

*N*athan loves owls. And so his attentive parents scoured the aisles of the local flea market looking for them. First they bought an owl thimble, then an owl doorstop, an owl puppet, an owl painting, an owl cookie jar . . . you get the idea. Nathan's job was to spot the owls among the clutter, leaving his parents to do the haggling. They soon learned that some owls don't come cheap, even to flea market aficionados. So when he was old enough, Nathan became the negotiator. Picking up the owl item, seven-year-old Nathan would approach the owner to ask "How much?" Unused to haggling with second graders, the owner would invariably give the owl to Nathan. The family owl collection now has more than two hundred items thanks to Nathan's entrepreneurial spirit.

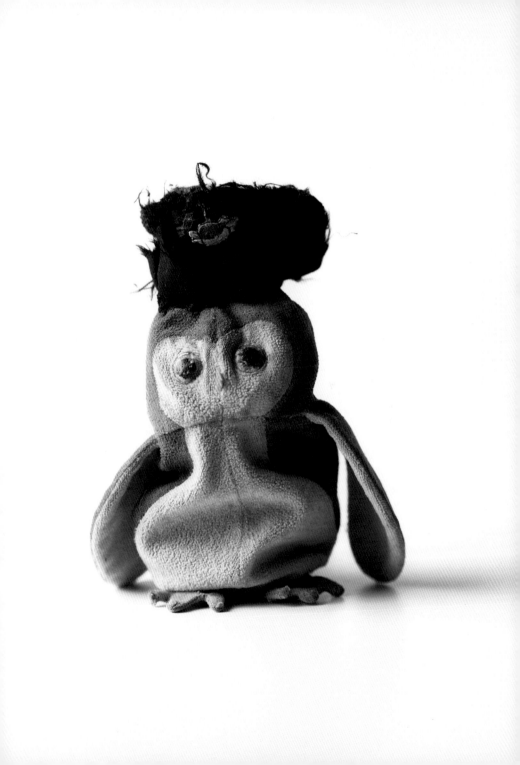

DUP DUP

\mathscr{A}s is the case with many of these love objects, this isn't the original Dup Dup.

Molly, Dup Dup's owner, had become quite adept at skidding around the kitchen in her baby walker—a kind of baby bumper car that Molly's mother surmises may now be illegal. Although the opening of the garbage pail was above Molly's head, she had a penchant for baby basketball, and the pail became an irresistible target.

One day, Dup Dup went missing. Weeks later, Molly's mom witnessed Molly executing a perfect layup with a pacifier and realized that the trash man had unwittingly delivered Dup Dup to the town dump.

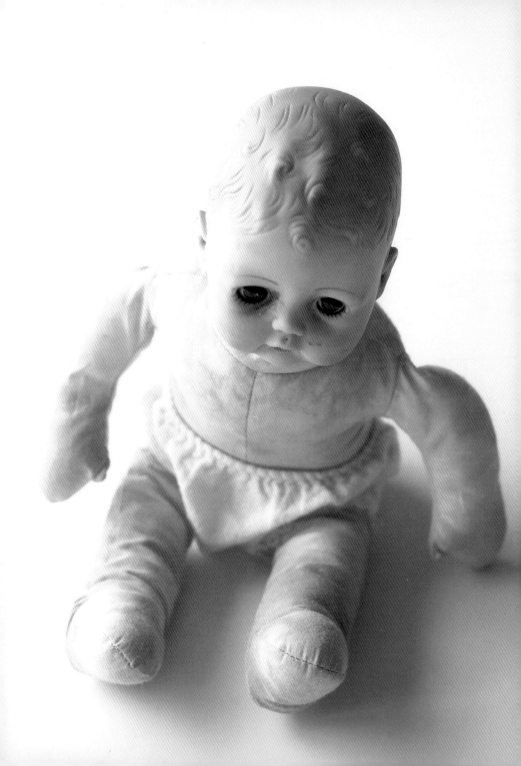

SNOWINGS

*W*hen Snowings was new she lived in a drafty hilltop house overlooking the sea. Her chief responsibility was to keep the ocean chill off Edie, something Snowings never failed to accomplish. It's hard to believe that Snowings still looks as fresh as powder—truth is, she's approaching middle age. Her youthful appearance could be attributed to genetic factors like a hearty constitution or strong fiber, but it's more likely due to the enormous amount of rest she's had while keeping Edie warm at night.

ELLIE FUNT

\mathcal{W}ell-loved childhood objects are undeniably soulful, but only rarely do they find true religion. Meet Ellie Funt. Sewn by a minister's wife for her granddaughter, Annie, Ellie Funt was a regular churchgoer for the first five years of her life. But when Annie left the fold, Ellie Funt's piety ended—the smell of incense and sound of hymns mere memories. Now an adult, Annie keeps Ellie Funt stowed in a plastic bin on the top shelf of her closet, and she likes to imagine Ellie safe and warm, recounting the lessons of her childhood sermons to her numerous bin mates.

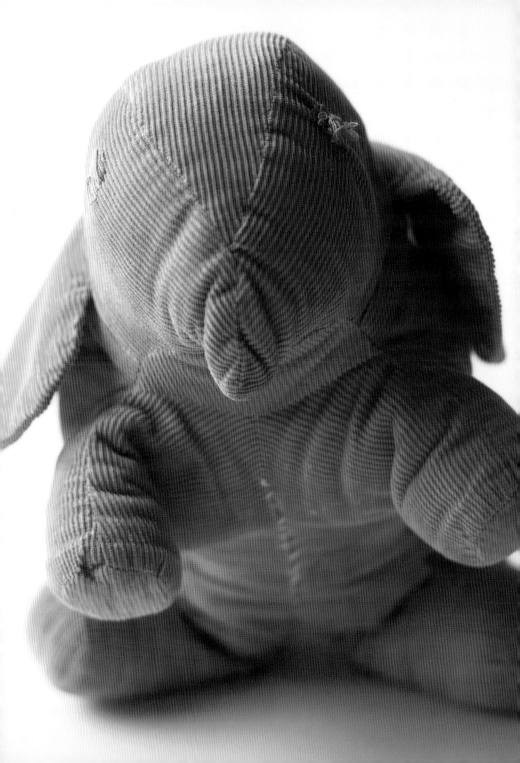

BUNNY

*B*unny got eaten by the family dog in an era well before eBay. The only replacement that even vaguely resembled Bunny–whose swishy fabric and jiggly legs Trevor adored–was this Christmas mouse, who, contrary to visual logic, is also called *Bunny*.

Trevor is now thirteen. He's unable to speak, so his parents aren't sure how much of what they say to him is understood. A few years ago, when Trevor's mom was putting him to bed, Bunny was nowhere to be found. Trevor's mom tucked him in, kissed him good night, and said, "I guess Bunny will have to sleep without you tonight." She left his room and went into the den. Soon Trevor wandered in, crawled under the coffee table, and with actions that spoke much louder than words, pulled Bunny from his hiding spot.

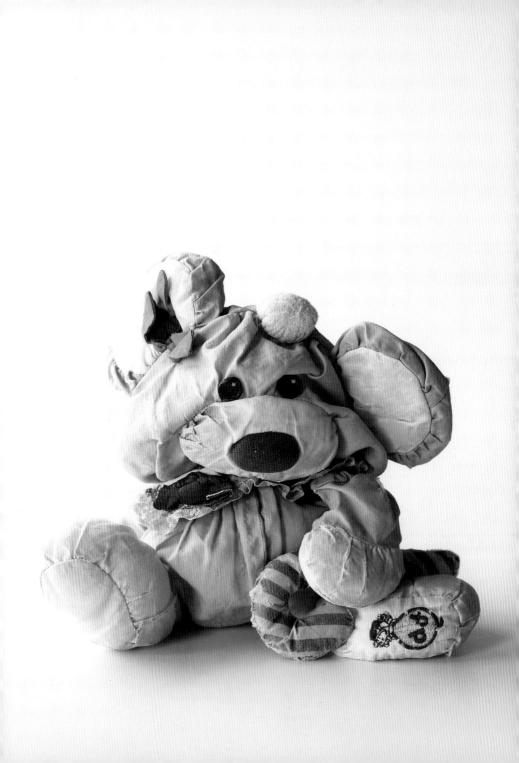

FRANKIE

*F*rankie came into Nick's life by mistake. He arrived at Nick's house in a box from the local hospital, accompanied by a note to Nick from "Uncle So-and-So, with best wishes for a speedy recovery." Nick wasn't sick, but apparently *some* Nick had already been discharged . . . or worse. Nick's physician mom immediately understood the confusion and called the hospital to return Frankie to the right Nick. The hospital's response was rather terse: "No, we cannot give you his address or phone number, and no, you cannot return the bear." What to do, but stash him away? One day, the now orphaned Frankie was discovered in his box by Nick—and they've been a happy, healthy pair ever since.

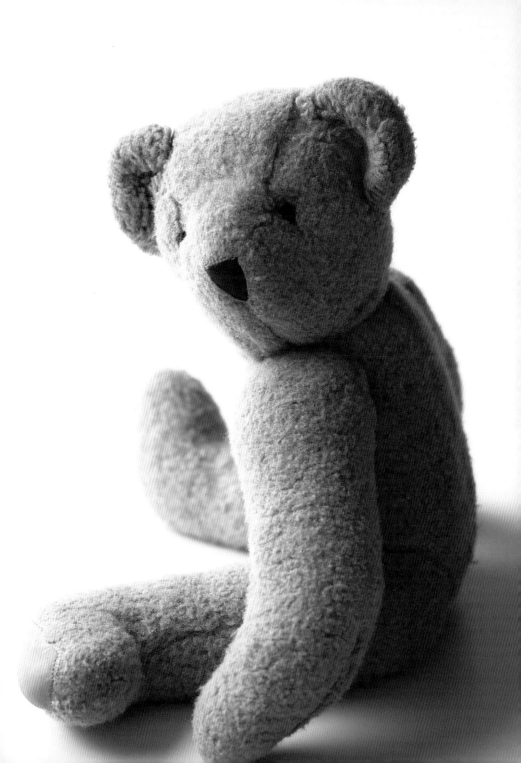

EDWARD AND OLIVE

\mathscr{O}nce Ben's psychologist mom understood just how attached Ben had become to Edward, she bought a backup "to prevent potential trauma," as psychologists are wont to do. Curious toddler that he was, Ben found the backup and promptly named her Olive–Edward's sister. With no more backups in the house, Ben invented an imaginary daddy elephant and named him Eject. He never got around to inventing a mommy elephant, but if he had, we imagine she might have been called Rewind.

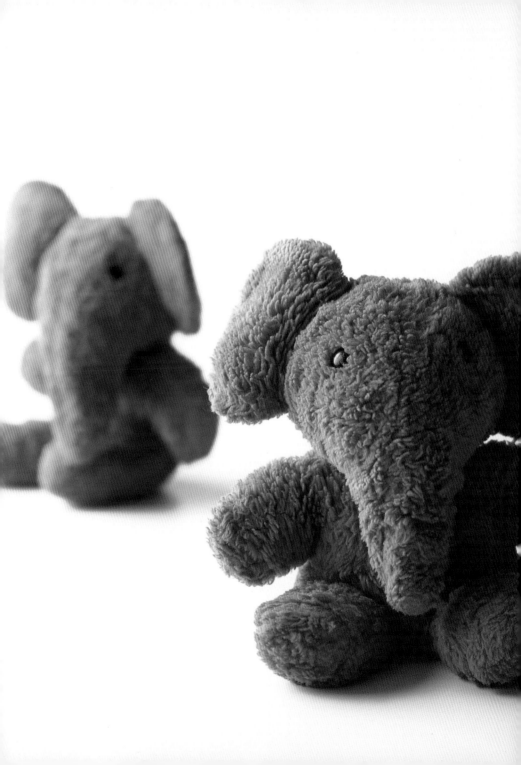

SIPPY

*W*ell read, well traveled, and very smart, Alice can be counted on to charm dinner companions with stories. This tendency is, perhaps, the result of Alice's relationship with Sippy. Sippy was presented to Alice by her mother, who considered the elf to be more presentable than a blanket and more socially acceptable than a bottle. Alice's mother felt that Alice and Sippy could enjoy a mature, "talking " relationship, which is what they had—sharing tales and conversing long after the lights went out.

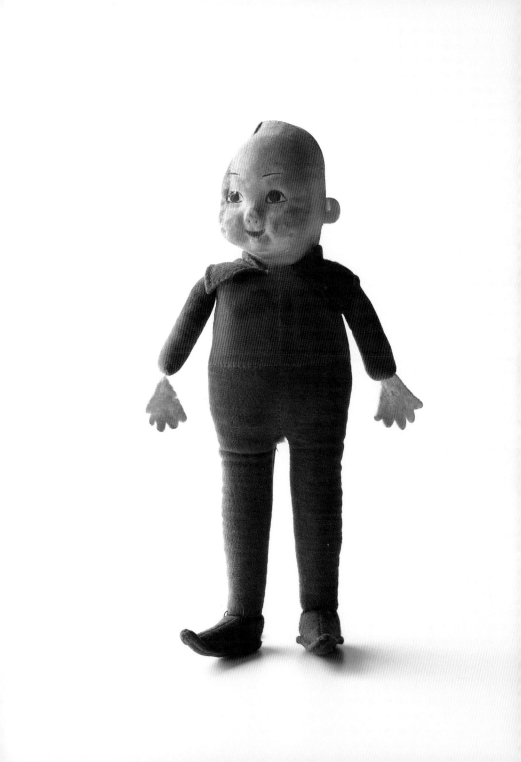

RAGS

Of all the blankets and stuffed toys that Mia was given when she arrived from China at ten months old, Rags became her favorite. She dragged it with her wherever she went, never letting it out of her sight. Whenever Mia's mother was able to extricate Rags from her sleeping daughter's hand, she would give it a thorough washing. But even the gentlest cycle wasn't gentle enough to prevent Rags from becoming an elegant tangle. No worries; Mia loves it just the same, carrying Rags slung across her body like a courier bag or piled atop her head like an exotic headdress. Her beloved Rags—now her favorite fashion accessory.

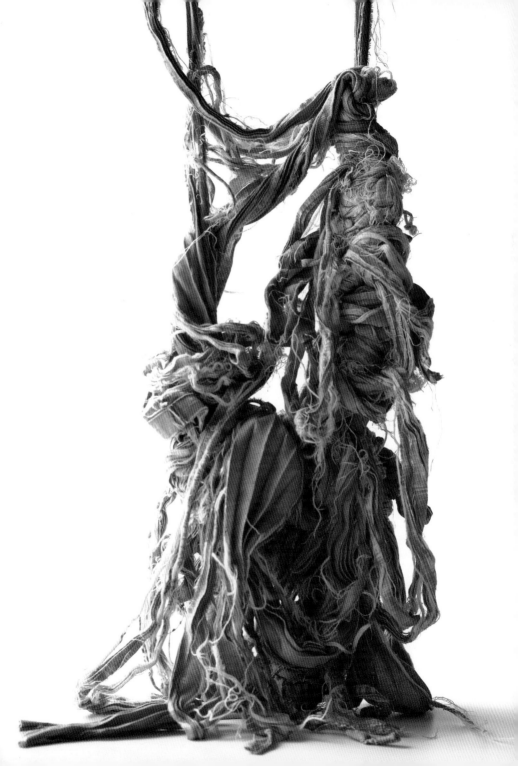

ROVER

*R*over has strong family ties. When Scott inherited him from his older brother, it was clear that Rover's neck was vulnerable. To avoid decapitation, Rover's neck required constant reinforcement. Luckily, Scott was an excellent caretaker. He convinced his grandfather to make a custom bed, asked his grandmother to fit it with a hand-sewn mattress, and cajoled his cousin to embroider a velour pillow with Rover's monogram. With Rover now confined to permanent bed rest, Scott has ensured that he resides in the lap of luxury.

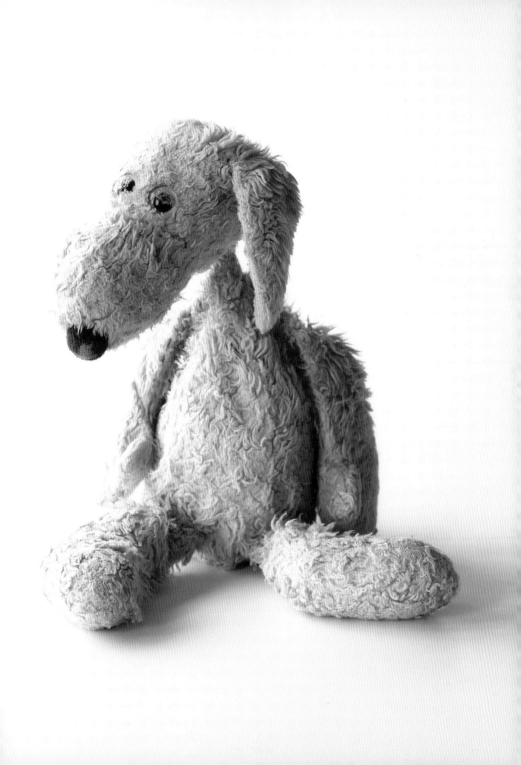

PANDA BRAND

A good rule of thumb when giving a gift is to choose something that you would want to receive. Even at three years old, Rebecca and her twin sister, Elyssa, had a sophisticated understanding of this principle. When their mother took them to the mall to choose a gift for their father's birthday, the girls chose Panda Brand.

Naturally, their father was thrilled with Rebecca and Elyssa's thoughtfulness, but admittedly uneasy with their request that he play with Panda and sleep with Panda. Every night. Not wanting to disappoint the girls or belittle their generosity, Dad honored their demands—until he developed a mysterious allergy to the bear. The girls, gracious as ever, offered to take care of Panda Brand for their father. And twenty years later, they still do.

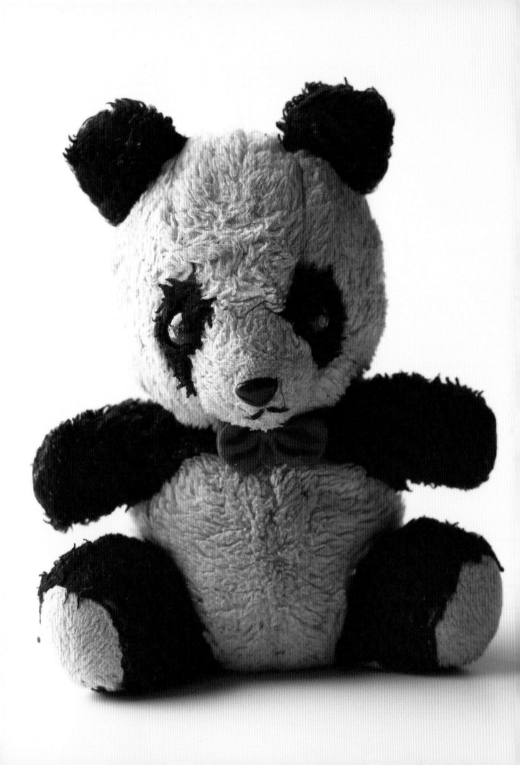

Flurry has a split personality. There's Flurry the nebbish homebody, who will lie perfectly still for hours and adjust her leg just so, as to allow Ibby to rest her nose in one particular spot when she sleeps. Then there's Flurry the party animal, who stays out all night at slumber parties. That side of Flurry parties so hard that although she was once a unicorn with a long white mane and a rose garland around her neck, what you see is what she had become by age eleven. Homey Flurry doesn't mind that her horn and coat have seen better days, because she never leaves the house anyway. And Floozy Flurry doesn't mind, because she's too busy socializing to look in a mirror.

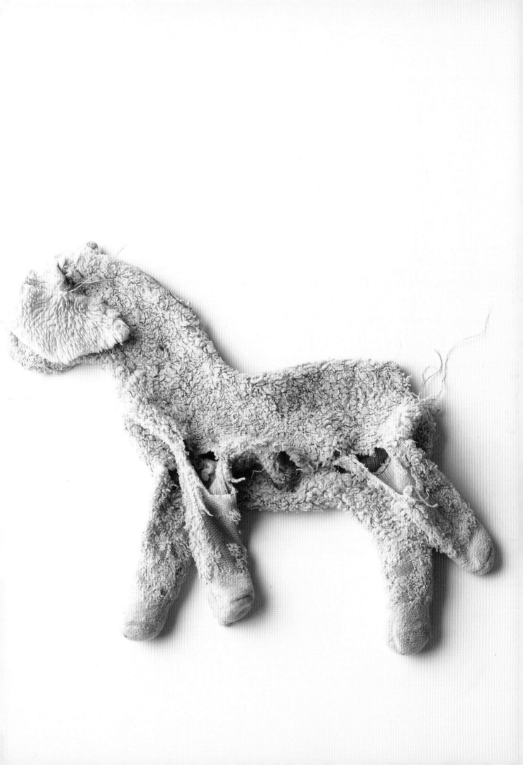

PUGGY

With a pair of mismatched eyes—the result of innocent but overzealous play by Lorri's niece—Puggy isn't perfect, which is exactly why Lorri finds him beautiful. Forgotten and abandoned in the bedroom closet at Lorri's parents' house, Puggy was rescued just before the moving vans whisked him away to Florida. Lorri brought him home to live with her and fell in love with him all over again. Now an art dealer, Lorri is drawn to outsider art that is reminiscent of Puggy's gaze—penetrating, naive, and a little off center.

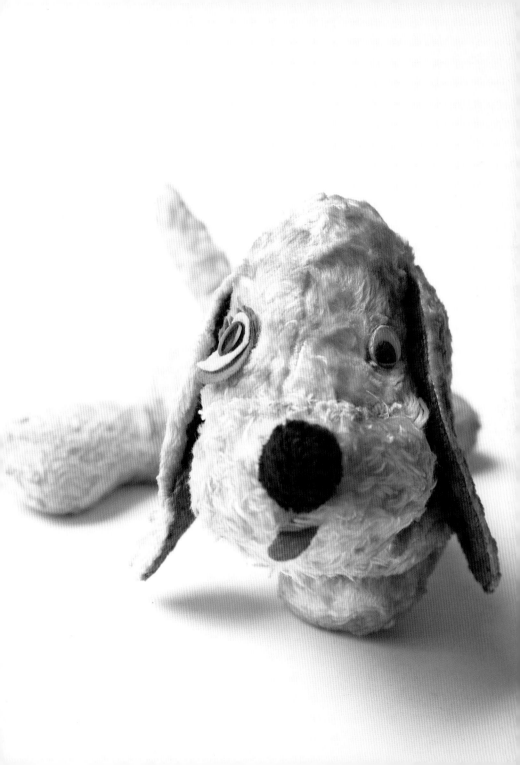

UP, UP & AWAY

One day Matt brought his sock monkey to school for show-and-tell. Usually a shy and introverted child, Matt was emboldened by the sudden and unusual attention and decided to show off his monkey's derring-do by frantically twirling it over his head. The monkey slipped out of Matt's little hand and flew "up, up, and away," landing face down on the far side of the show-and-tell circle. Not only was the monkey's left arm stretched a bit, but his eyes also came unglued. At least the name stuck.

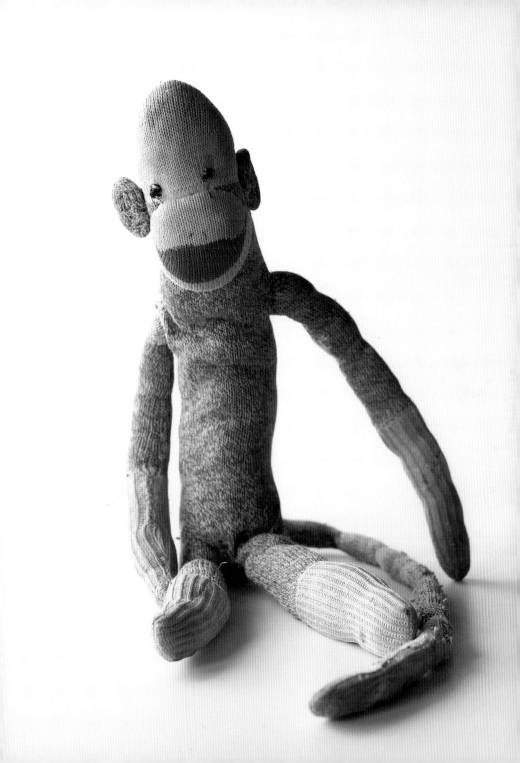

KATIE KITTENHEART

*W*hen seven-year-old Alexandra spotted Katie Kittenheart in an upscale Pittsburgh toy store, she had to have her. Katie's startling blue eyes were hidden under an adorable puff of real white rabbit fur, so you could see them only by gently blowing on her. Though Alex didn't have a cat of her own, she possessed a modicum of understanding about feline grooming techniques, and she took to tidying up Miss Kittenheart with her own little human tongue baths. Small wonder that twenty-seven years later, Katie Kittenheart still looks alarmed.

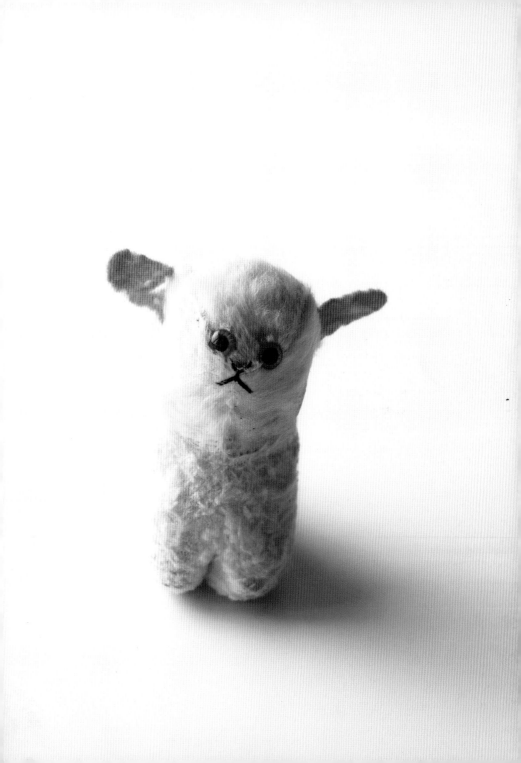

RALPH

*I*t's a mystery to all but the preverbal owner why one toy or blanket gets chosen over all the others, but Ralph has a special, if somewhat calculated, appeal. With a doggy head and a blankie body, he had double the chance of all the other candidates.

Once an object is deemed special, many parents keep a spare on hand to ward off the chaos that would ensue should, heaven forbid, a disappearance occur. To procure an emergency replacement, Ian's mother turned to the Internet. An astonishingly successful bout of web surfing produced not one, not two, but nine Ralphs. Just as Ian finds safety in what he thinks is his one-and-only constant companion, his mother finds safety in numbers.

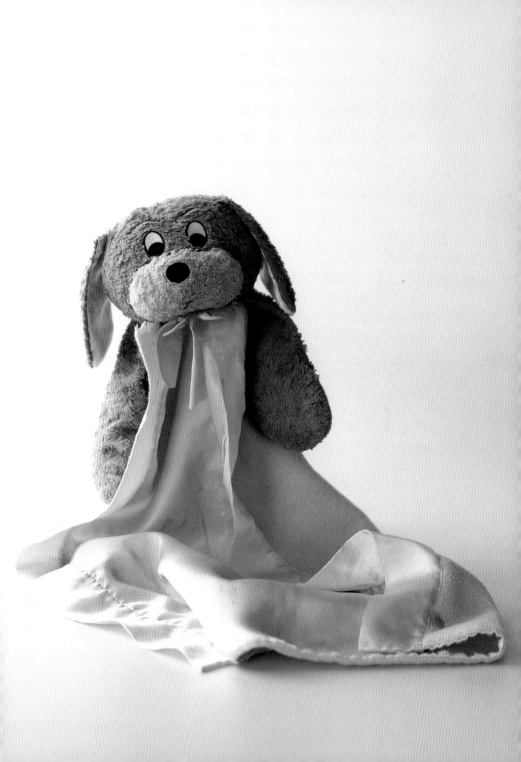

PICKLE

Though Heinz may boast fifty-seven varieties, Louise is convinced that there's only one Pickle. Pickle came into Louise's life when she was about two years old and accompanied her wherever she went until the day Pickle was inadvertently left behind on a family trip to New Hampshire. Though Pickle was safely returned to Louise in a package marked "Pickle Express," Louise made it clear that Pickle's traveling days were over. Louise no longer lives in the same town as Pickle, so Pickle waits patiently for the days when Louise returns home for a visit. And no, Pickle isn't sour about being left behind, because she's a sweet Pickle.

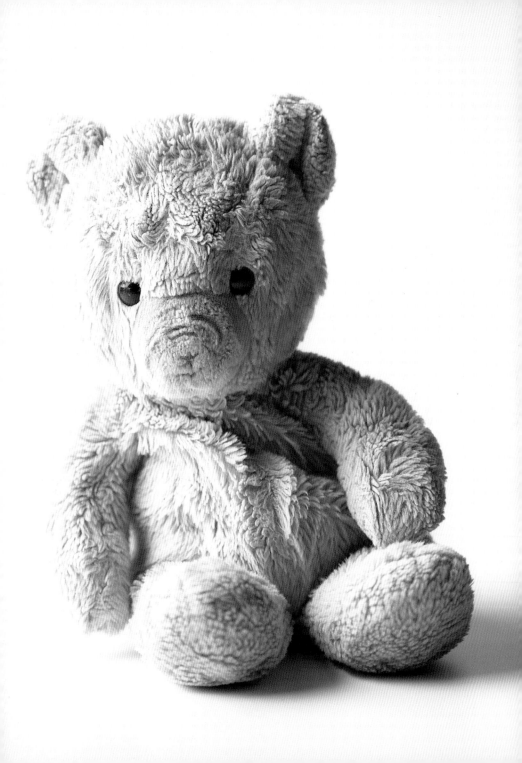

FUZZY

A name like *Fuzzy* sets up certain expectations. And although this Fuzzy is still fairly fuzzy, he's not nearly as fuzzy as he once was. After all, a well-loved bear is never simply a ne'er-do-well layabout (which would offer the advantage of keeping a bear looking brand-spanking-new); this guy worked hard for his keep.

Serious kid that she was, Melissa imagined that she'd grow up to be a paramedic. Fuzzy was often pressed into service to play the victim of a disaster, thus allowing Melissa to get a jump start on her career training. One day, however, Fuzzy's mock victim role took a too-real turn. Melissa had the stomach flu, and Fuzzy got in the way of the eruptions. Many washings later, Fuzzy was a decidedly less fuzzy Fuzzy.

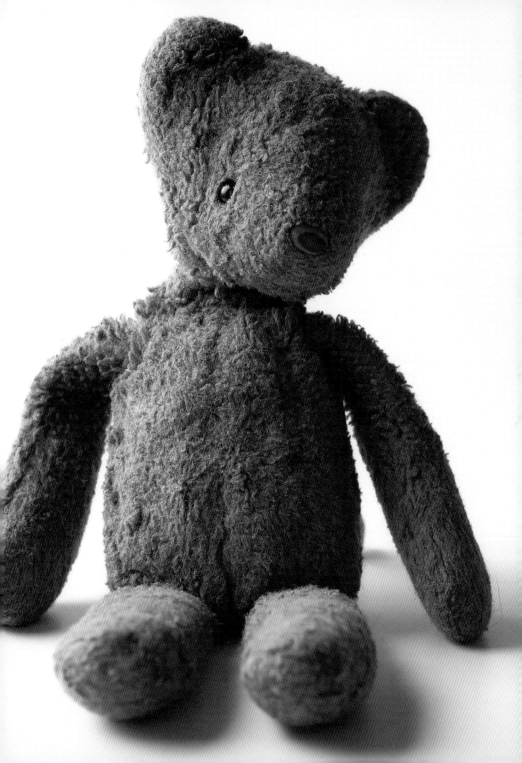

WEDNESDAY

*I*n late 1960, with forged papers and just twelve hours' notice, Ann's family fled Cuba with one suitcase—a ruse to convince the authorities that the family was taking a week-long vacation. The ruse fooled the fourteen-year-old Ann as well, who was shocked to learn that her parents had no intention of ever returning to Cuba.

Though her mother felt that Ann was too old for dolls, she did realize that Ann needed something for companionship. Wednesday passed muster because she was anything but babyish. The glum daughter from *The Addams Family*, Wednesday accompanied Ann everywhere as she made the transition to this new and scary land. If Wednesday was a safe harbor for Ann back then, Ann has returned the favor. Wednesday's safe harbor is Ann's bureau, where she resides to this day.

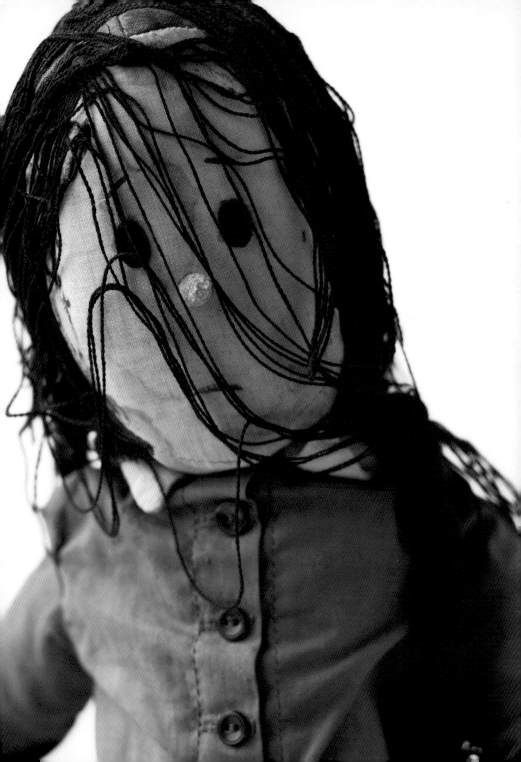